My Journey
Illustrated & Designed by
Alison RH Liu

www.ingramcontent.com/pod-product-compliance
Lightning Source LLC
Chambersburg PA
CBHW071207220526
45468CB00002B/533